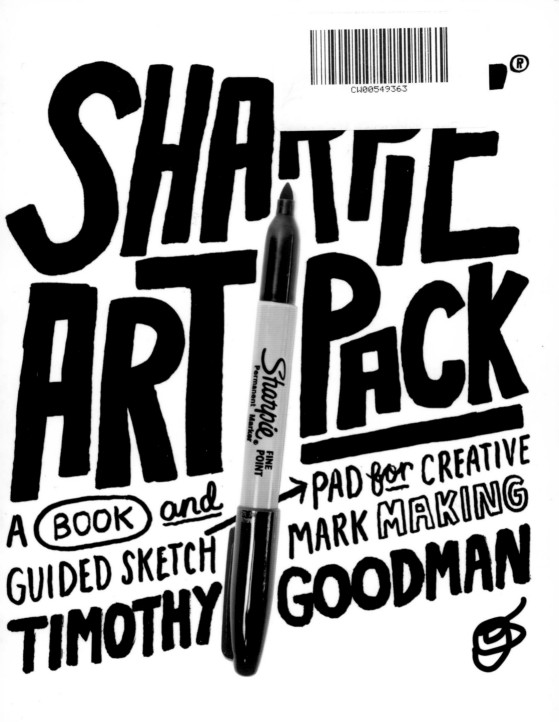

Sharpie® Art Pack

A BOOK and GUIDED SKETCH → PAD for CREATIVE MARK MAKING

Sharpie® Permanent Marker FINE POINT

TIMOTHY GOODMAN

SHARPIE® ART PACK

A BOOK and GUIDED SKETCH PAD for CREATIVE MARK MAKING

TIMOTHY GOODMAN

ROCKPORT

COPYRIGHT

Quarto is the authority on a wide range of topics.

Quarto educates, entertains and enriches the lives of our readers—enthusiasts and lovers of hands-on living.

www.QuartoKnows.com

First published in the United States of America in 2016 by
Rockport Publishers, an imprint of
Quarto Publishing Group USA Inc.
100 Cummings Center
Suite 406-L
Beverly, Massachusetts 01915-6101
Telephone: (978) 282-9590
Fax: (978) 283-2742
QuartoKnows.com
Visit our blogs at QuartoKnows.com

10 9 8 7 6 5 4 3 2 1

ISBN: 978-1-63159-119-8

Book design: Daniel Blackman and Timothy Goodman
Original photography: Daniel Blackman
Cover design: Timothy Goodman

Printed in China

TOC

ART IS WHATEVER YOU CAN GET AWAY WITH. NO RULES.

Yes, Sharpie® markers are the number-one selling permanent marker in the world, but what makes Sharpie so special to me personally is that it crosses over into so many genres, cultures, backgrounds, ages, and beliefs. Sharpie markers are amazingly versatile and completely free of controversy. Athletes use them to sign autographs; kids use them to draw pictures; artists use them in their work; some people might use them to touch up a scratch on their piano; my mom uses them to write a grocery list; and I use them to draw on anything I can get my hands on.

An old teacher of mine always said, "If you want to change your look, then change your tool." Five years ago, I made a decision to get my hand in my work more. It all started when I had the opportunity to do a mural for the Ace Hotel in New York City. I locked myself in this hotel room for three days with a Sharpie paint marker and I never looked back. That project has since changed the trajectory of my entire career. I went from being a more traditional graphic designer working in branding to working for myself creating a variety of murals and installations for clients all over the world.

This book will explore effects, techniques, mediums, and ideas about how to use Sharpie markers in your life. From making handmade gifts to creating murals to repurposing old objects to simply doodling in your notebook, we can bring a tremendous amount of creativity and joy to ourselves and those in our life. Furthermore, this book will be a catalog of inspiration from successful artists and illustrators who use Sharpie markers all over the world. Some have been teachers of mine; others are peers of mine; and some I'm honored to call friends.

I want to give new ideas and inspiration to the young artist, aspiration to the nonartist who's looking to be creative and express themselves, and I want to bring context to why and how we can use Sharpie. As cliché as it is, I strongly believe that when you have a Sharpie the world is your canvas. I want to encourage everyone to engage and participate in the world of Sharpie markers.

—TIMOTHY GOODMAN

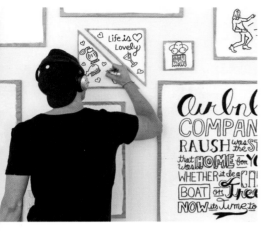

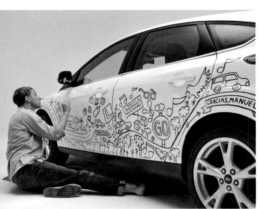

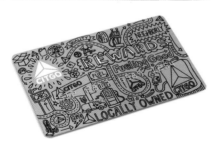

Top, left: Installation for Airbnb's offices in San Francisco, where I cut, painted, and drew on 115 pieces of plywood; middle, left: Installation for Ford Europe, where I illustrated stories from Focus owners in London and Paris; bottom, left: Illustration design for Citgo gas station credit cards; top, right: Magazine covers for *Time* and *New York*; bottom, right: Mural of Tupac lyrics at a trade-show for FlexFit headwear in Las Vegas, Nevada.

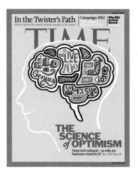

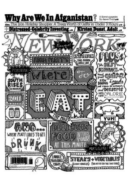

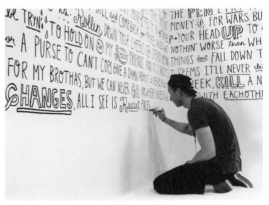

Want to make a mark? Sure! Want to draw a pattern on a piece of paper? Of course! Want to draw all over that old object in your house? Why not! Want to make a gift for someone? Definitely! Want to draw on your sneakers? Even better! Want to draw on your wall? Be my guest! Want to bring new meaning to old things? You're in the right place!

Like anything in life, the more you practice and work at something, the better your instincts become. However, how do you know what's the right Sharpie for you to use? Would you know the right kind of knife to use if you've never cut a piece of meat? Would you know the right blade to use to carve a piece of wood? This section will explore an assortment of materials and objects that you can use, as well as the ins and outs of each kind of Sharpie marker. No matter which kind you use or how you use it, everything is begging for your imagination to run wild.

Hopefully I can open your eyes and expand your horizons on all the ways you can use Sharpie in your life. Remember, as Andy Warhol said, "Art is whatever you can get away with." So let's get away with some stuff!

WANT TO CHANGE YOUR LOOK? THEN CHANGE YOUR TOOL.

Sharpie Pen:
Use it for taking notes, journaling, writing letters, making cards, and more. It won't bleed.

Sharpie Ultra-Fine Point:
Features a precise, narrowed tip for extreme control.

Sharpie Fine Point:
The industry standard—the Big Cheese, Mr. Popular.

Sharpie Twin Tip:
Functionality is increased with both fine and ultra-fine tips in one marker.

Sharpie Fabric:
Developed for optimal performance on most fabric surfaces, it uses fabric ink with a brush tip.

Sharpie Super Point:
The bolder the better! A super-large ink supply extends the product's life.

Sharpie Paint Bold Point:
Use on virtually any surface:
metal, pottery, wood, rubber,
glass, plastic, stone, and more.

Sharpie Paint Medium Point:
A thinner version, used on
virtually any surface: metal,
pottery, wood, rubber, glass,
plastic, stone, and more.

Sharpie Brush:
Creates fine lines, bold
strokes, and shading.
Control the width of your
lines from your hand.

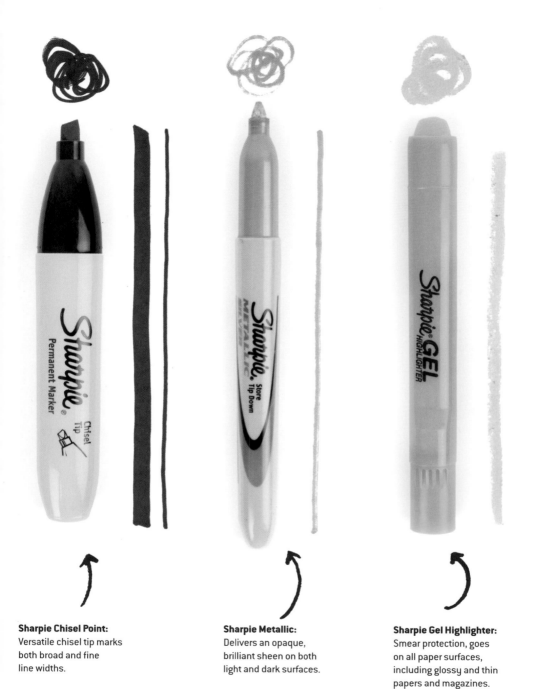

Sharpie Chisel Point:
Versatile chisel tip marks both broad and fine line widths.

Sharpie Metallic:
Delivers an opaque, brilliant sheen on both light and dark surfaces.

Sharpie Gel Highlighter:
Smear protection, goes on all paper surfaces, including glossy and thin papers and magazines.

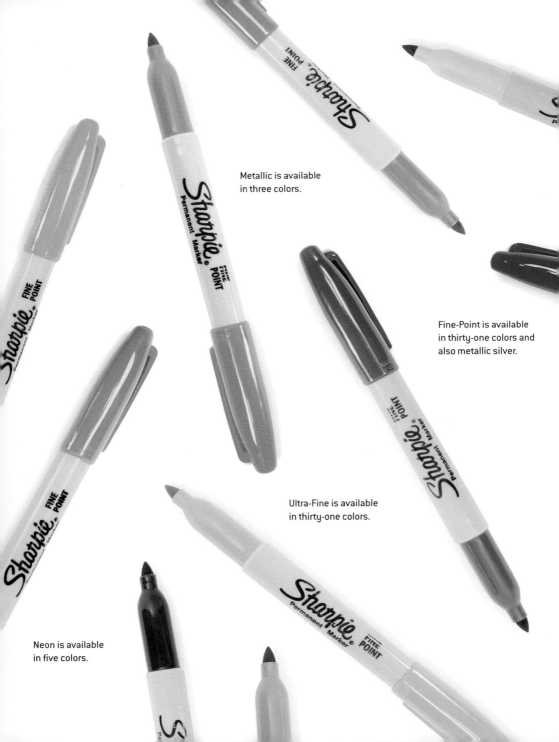

Metallic is available in three colors.

Fine-Point is available in thirty-one colors and also metallic silver.

Ultra-Fine is available in thirty-one colors.

Neon is available in five colors.

Grip and Chisel Tip are
available in eight colors.

Ultra-Fine and Super
Sharpie are available
in four colors.

Twin-Tip is available
in twenty colors.

HISTORY + FACTS

Sharpie was invented in 1964, and it's the number-one selling permanent marker in the world. It has been used from autograph signing to fine art to touching up scratches on cars or pianos. Sharpie can be found in office supply stores, drugstores, and almost anywhere writing utensils are sold. They are available across the globe in almost every country, in several tip sizes, in over thirty colors.

49 SHARPIE COLORS

1964

The Sharpie marker was created by the Sanford Manufacturing Company in 1964 as the first permanent marker. Johnny Carson and Jack Parr endorsed Sharpie on their shows.

1952

The Sharpie marker was a refinement of an earlier invention, the Magic Marker felt-tip marker. The Magic Marker was invented by Sidney Rosenthal in 1952 in New York City and manufactured by his company, Speedry Chemical Products.

3,200 BC

The use of ink for writing and printing dates back to 3,200 BC, when the Egyptians used a mixture of fine soot and vegetable gum to create a substance that could be used for writing and painting.

SHARPIES ARE SOLD IN 20 COUNTRIES

1857

Sanford was started by Frederick W. Redington, Tom Sharp, and William H. Sanford Jr. in 1857 in Worcester, Mississippi, as a manufacturer of ink and glue.

It was distinguished from earlier markers by its penlike shape and ability to write permanently on a variety of surfaces—stone, wood, glass, metal, plastic, and paper.

"PERMANENT" MARKER MEANS THE INK CONTAINS DYE OR PIGMENTS

1979

A new style tip was introduced in four colors: the Sharpie Extra-Fine Point marker.

Autograph seekers and celebrities alike use Sharpie markers on everything from posters and trading cards to balls and jerseys.

President George W. Bush was a fan of Sharpie. Bush reportedly preferred Sharpie markers to all other writing instruments and had a personalized version with his signature and "The White House" imprinted on it.

1992

In 1992 Sharpie was acquired by the Newell Companies.

In October 2002, the Sharpie marker made news on *Monday Night Football*. After scoring on a 50-yard touchdown pass for the San Francisco 49ers, Terrell Owens produced a Sharpie marker he had stored in his sock, autographed the ball with which he had just scored, and passed it to his financial advisor.

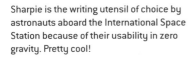

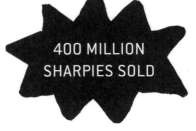

400 MILLION SHARPIES SOLD

Sharpie is the writing utensil of choice by astronauts aboard the International Space Station because of their usability in zero gravity. Pretty cool!

APPROACH CREATIVITY AS A PRACTICE, NOT AS A PROFESSION.

I always tell my graphic design students at the School of Visual Arts in New York City, to approach design as an exercise or a practice, not as a profession.

By definition, an exercise is an activity done to practice a skill. It's a process carried out for a specific purpose. And what better purpose do you need when you have a Sharpie? Personally, I never wanted to be a professional. I only wanted to have the opportunity to make stuff I love. Some stuff you get paid to make and some stuff you make for yourself, but all of it is a useful exercise in creativity. Sharpie is nothing but a tool for your creativity. It's the means for a creative process, a chance to make something beautiful, and an excuse to make a beautiful mess. For me, it's the chance to flip a cliché, to make the expected unexpected.

This section is the lion's share of the book. We will explore many different exercises that can inspire you to think differently about what a Sharpie can do for you. Some are very accessible, some are a bit more ambitious, and some are just eye candy. However, no matter what you decide to do, take your time, have fun, and enjoy the process! There are no rules.

MARK MAKING

Like athletes, creative people need to loosen up and stretch before the big game. Simple mark-making exercises and activities are a great way to get the mind going and the blood flowing. Some people make abstract marks and scribbles, some try out brush techniques, while others practice with lettering and words.

Often times in the morning, I'll sit down with my tea (I don't drink coffee!) and my Sharpie Brush Tip and make scribbles or write out words in different ways. I often make marks in my notebook while I'm on the phone, too. I find it increasingly important for me to carry Sharpie markers and my notebook with me whenever I'm out, in case any ideas come to mind. I find the idea that I can draw anywhere at anytime extremely liberating. It's also a great way to be spontaneous when meeting a friend for coffee (or tea)!

Mireia Ruiz
I love how Mireia uses people against backgrounds filled with simple marks. This is a piece for the clothing company, MMVIII.ca

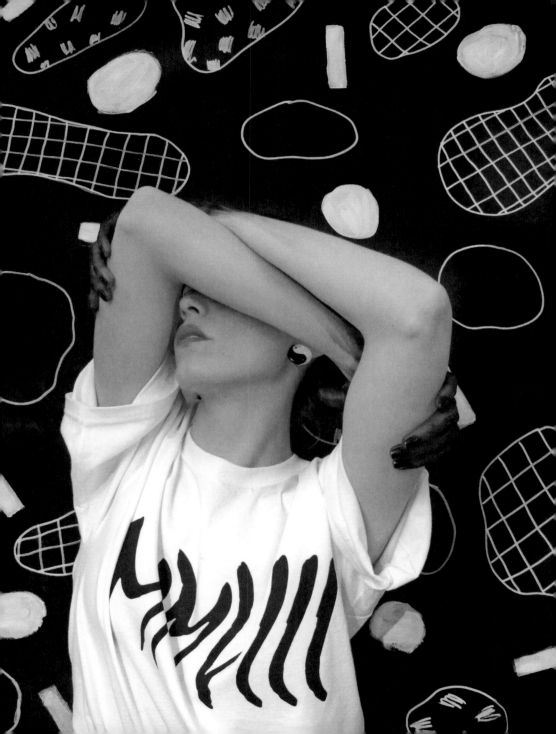

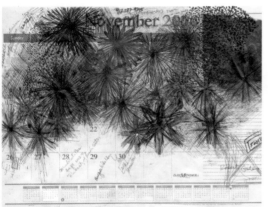

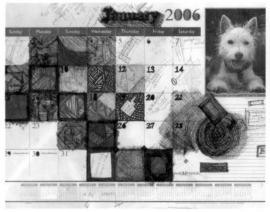

Carolyn Hinkson-Jenkins
New York, New York

Carolyn Hinkson-Jenkins has been the director
of operations for the BFA Advertising and BFA
Design Departments at the School of Visual
Arts in New York City for over fifteen years. She
holds a BA from Hunter College and a MS Ed.
from Baruch College. The images shown here
were the result of her obsession with covering
a blank calendar page while on the phone.
As you see in the intensity of her strokes,
some days were better than others. However,
the results were all a labor of love.

Mireia Ruiz
Barcelona, Spain

I absolutely adore Mireia's use of mark making and they way she uses photography to capture it. Mireia is a graphic designer who studied at Bau Design College of Barcelona. After forming part of DGestudio, she joined Cocolia, where she took charge of art direction. Today, together with Raul Ramos, they direct the studio. She combines her profession of graphic design with illustration, and participates in various artistic and creative projects. Check out her gorgeous work here: mireiaruiz.com.

COMMERCE HIERARC

PRIÉTÉ FISCAL

ATION

INSÉCURI

NTRE LEGISLATION T @

Histoire FAMILLE F

MORALE Culture

TRADITION

RELIGION ÉDUCATION PLOUTO

N!

CE INDUSTRIE CHÔMA

OUI + CLASSE JUSTIC

Bureaucratie

PLAY NICE

American mythologist Joseph Campbell said, "What did you do as a child that created timelessness, that made you forget time? There lies the myth to live by." This section is not that different from the previous mark-making section. However, I think it's important to understand a couple things about the idea of "play." When you engage in a creative activity for enjoyment and recreation rather than for serious or practical purposes, you can obviously have a lot of fun, but you can also get back to the root of something that you forgot you had.

Many creative people need to play before they get serious with their work. Personally, I will draw the same thing over and over again when I'm on an idea. I believe that the idea of playing is something that can be very meaningful to you in your practice, if you take time to discover and foster it. I hope this book will help push you to the unexpected.

Yann Le Dluz
Yann is an illustrator and designer based in Paris, France, who definitely knows how to play! Check out his work here: yannzuldel.com.

Jen Mussari
Brooklyn, New York

Jen is a lettering artist, illustrator, and designer. Some of her clients include Squarespace, Airbnb, Kickstarter, Shopify, Patagonia, Art Directors Club, EMI/Capitol Records, Target, West Elm, Penguin Books, and Adobe. I love all her work, but I specifically love her whimsical process drawings here on this spread. You can tell she likes to play! Check out the rest of her work here: jenmussari.com.

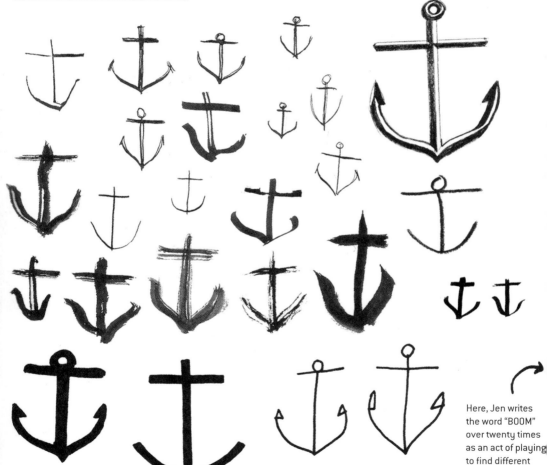

Here, Jen writes the word "BOOM" over twenty times as an act of playing to find different outcomes.

PRACTICE
PRACTICE
PRACTICE
PRACTICE
PRACTICE
PRACTICE
PRACTICE

REFINING

Tracing paper is one of those hidden secrets no one tells you about when it comes to refining your work. Once you get an idea out on paper it's still usually messy and very much in the process stage. Most times, I don't do something amazing the first time at it, and it's imperative that I keep reworking it and reworking it. Tracing paper, with its low opacity, allows me to keep refining on top of my original drawing, and my second drawing, and my third drawing, until it gets to a place that I'm happy with.

Tracing paper is my parachute. It's my bulletproof vest. It's my cheat sheet. It allows me to get away with anything I want. Tracing paper is my best friend while I'm working, and I want you to make friends with it, too. Buy a roll or a pad (I prefer the rolls!) at any local art store or places like Target, Walmart, or Staples. Have fun, please!

en Mussari
ere's more of Jen's
rocess and how
he refines with
acing paper!

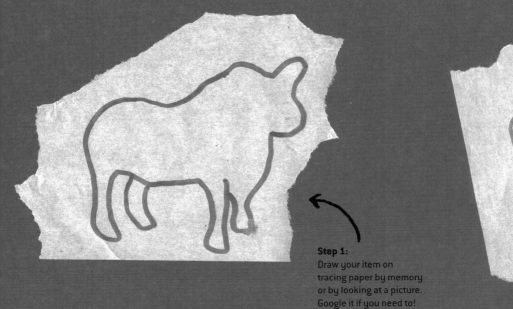

Step 1:
Draw your item on
tracing paper by memory
or by looking at a picture.
Google it if you need to!

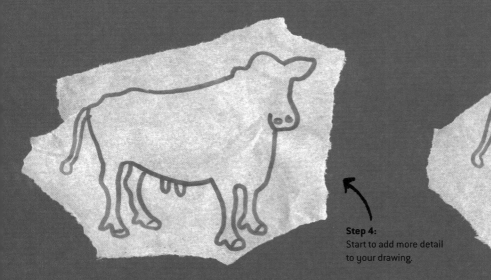

Step 4:
Start to add more detail
to your drawing.

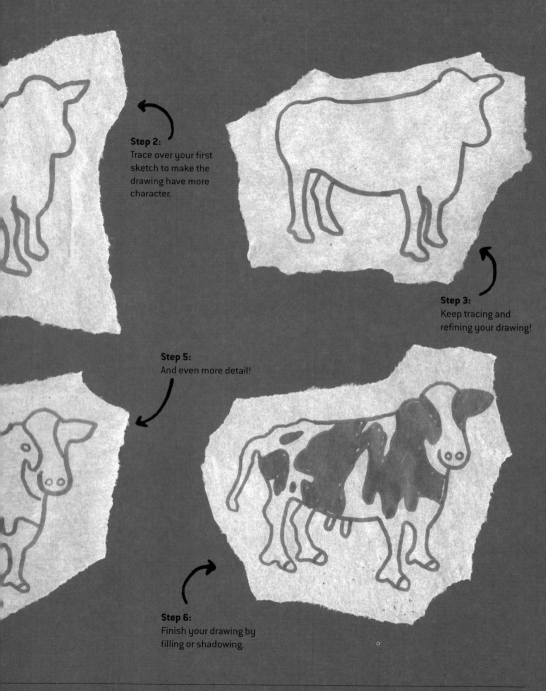

Step 2:
Trace over your first sketch to make the drawing have more character.

Step 3:
Keep tracing and refining your drawing!

Step 5:
And even more detail!

Step 6:
Finish your drawing by filling or shadowing.

DOODLE as ART

Here's Wikipedia's definition of what a doodle is: "An unfocused or unconscious drawing made while a person's attention is otherwise occupied. Doodles are simple drawings that can have concrete representational meaning or may just be abstract shapes."

Some illustrators I know have a problem with this term. They feel it cheapens or lessens a creative technique that is actually very hard to pull off. Personally, I don't have an issue with the term. Doodling can be a great way to express yourself, both consciously and unconsciously. Sometimes, we doodle to kill time in a boring meeting, sometimes we doodle when we're on the phone, and some of us have made the doodling technique a way of life. Either way you do it, doodling is a great way to express yourself. It frees you from the way you think things should be and allows your imagination to run wild. Have fun!

Kate Bingaman-B
Kate's awesome drawings here can be seen on packaging and campaigns for Chipotle.

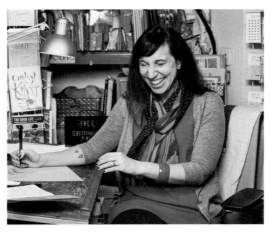

Kate Bingaman-Burt
Portland, Oregon

I love Kate Bingaman-Burt's lighthearted and whimsical touch. Kate is an amazing illustrator out of Portland who is also the faculty advisor for the Portland State University student design group, Friends of Graphic Design (FoGD). Her illustrations are very simple, but when put together, it becomes a very powerful way to tell a story. Below you can see her "Other People's Mixtapes" project. Check out her work here: katebingamanburt.com.

SIDE A ---> RECORDED (6.29.1986) SARAH GAVE this tape to her FIRST HusBand in 1986 & then she gave it to Zach in 2014. (1.) LOVE & ROCKETS / HAUNTED When minutes DRAG (2.) UV POP / SERIOUS (3.) Sisters / SOME Kind of Stranger (4.) CHAMELONS / Don't Fall (5.) B. MOVIE / ARCTIC Summer ---> intERmission (6.) SALVATION / JESSICA'S CRIME (7.) THE Mission / SERPENT'S Kiss ---> SIDE B! (9.) NEW ORDER / DREAMS NEVER END (10.) TEAR DROP ExPLODES / BENT out of SHAPE (13.) The DELLORDS / TRUE LOVE (14.) The SMiths / What DIFFERENCE Does it make? (intERmission) (15.) THE CURE (Own FAVE) SHAKE DOG SHAKE (16.) LET'S ACTIVE / FELL (17.) SiouXsie / Cities in Dust (18.) Comsat Angels / Missing in Action (19.) RED LORRY YELLOW LORRY / TEAR me Up ◆ (20.) Hollow EYE

[A] Haunted By You
maxell 90
A

(8.) The JESUS & MARY CHAIN / SOWING SEEDS * (11.) SOFT BOYS / KINGDOM of LO & INSanely (12.) JEALOUS

✱ A KELLEY NACE SUGGESTION

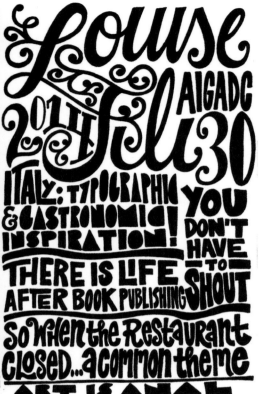

Louse

2011 AIGADC Feb 30

ITALY: TYPOGRAPHIC & GASTRONOMIC INSPIRATION!

YOU DON'T HAVE TO SHOUT

THERE IS LIFE AFTER BOOK PUBLISHING

So When the Restaurant Closed... a common theme

ART IS ANAL

DESIGNING FOR AUDIENCES W/ LOW-LITERACY SKILLS

LOW-LITERACY I USE LOTS OF SPACE

READERS MAY TAKE WORDS LITERALLY READ ONE WORD AT A TIME SKIP UNCOMMON WORDS NOT THINK IN CATEGORIES MISS THE CONTEXT TIRE QUICKLY

NEARLY HALF OF AMERICAN ADULTS HAVE LOW LITERACY SKILLS

SIMPLE TYPOGRAPHY MAKE IT VISUAL SIMPLIFY WRITING AVOID: HUMOR IDIOMS ALL CAPS ITALICS TALL X HEIGHT

RETAIN LITTLE I JARGON

Carolyn Sewell
Washington, DC

Carolyn Sewell is an illustrator and letterer who's been sketching in her Moleskine notebooks for years. She fills her notebook up with inspiring words and quotes from the design talks and conference she goes to. She shows her interpretation of the entire event through her beautiful style. Later, she revisits the drawings to better execute them. Check out her awesome work here: carolynsewell.com.

FUN WAYS to DOODLE

What is a doodle?

It's always good to know the definition of what it is you're going to try. Wikipedia says a doodle is "an unfocused or unconscious drawing made while a person's attention is otherwise occupied. Doodles are simple drawings that can have concrete representational meaning or may just be abstract shapes."

What Sharpie should you use?

You can doodle with any kind of Sharpie, but if you're doodling on a piece of paper or in a notebook, I probably wouldn't use the Sharpie paint markers or any other thick-tipped Sharpie for two reasons: You'll lose detail and it will soak through the pages. I personally love the felt-tip Sharpie markers because you can get a good variation of thick and thin lines. However, you can never go wrong with the Sharpie Fine Point! Experiment and find the one you love.

Where are you doing this?

Are you doodling in a notebook? On your wall? On your shoes? That will dictate the kind of marker you should use. The great thing about doodling is that you can doodle anywhere you want: on the train, at home, in class, at work, on the phone, in bed, when you're bored or excited.

What are you going to doodle about?

Is it just a random series of thoughts? Is it about one particular topic that you're currently interested in? I often doodle song lyrics or about relationships, and sometimes I just doodle while I'm on the phone. You could doodle your name or anything, really. There are no rules.

Carolyn Sewell
Here, we see how Carolyn refines the notes she takes from the design lectures she attends.

PATTERNS

Patterns, patterns, patterns, patterns! Patterns can be simple shapes; they can be complicated line work; and they can be objects, animals, typography, people, flowers, or really any repeated decorative design work. Patterns can work on literally anything in this book: dinnerware, Post-its, skateboards, frames, objects, envelopes, walls, gift wrapping, cards, shoes, you name it. Patterns can act as doodles; patterns can act as a warm-up; and patterns can even become words.

There is no limit to what can be done with patterns. What you want to do with them is really up to you. In this section, I will highlight different ways this can be done, as well as some extraordinary artists and illustrators who have made a name for themselves using patterns in unique ways. Enjoy!

Matti Vandersee I love this type pattern made by Matti, who is an illustrator based in Heredia, Costa Rica. Check out his work here: behance.net/vndlzr.

Julia Rothman
Brooklyn, New York

Julia Rothman works from her studio
in Brooklyn, New York. Some of her clients
include Chronicle Books, Target, Crate &
Barrel, Anthropologie, the *New York Times*,
the *Washington Post*, Urban Outfitters,
New York magazine, Storey Publishing,
and Victoria's Secret. Julia also has a book
blog where she writes and shows pictures
of art, design, comics, and children's
books that she thinks are nice. Check out
her work here: juliarothman.com and
her blog at book-by-its-cover.com.

Pattern of scribbles

Pattern of mark making

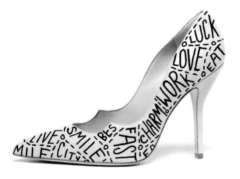

Pattern of words

Pattern of lines

Pattern of building doodles

Pattern of brick

MAKE a PATTERN

What is a pattern? A pattern is a repeated decorative design or an arrangement of sequences that can give a regular or intelligible form in comparable objects.

What Sharpie should you use? You can make a pattern with any kind of Sharpie marker, really. It just depends on the item you're drawing on. However, if you're drawing it on a piece of paper, I would probably stick to the fine-point or smaller. I personally love the felt-tip Sharpie markers because you can get a good variation of thick and thin lines.

What should you draw? The great thing about making a pattern is that you can literally turn anything into a pattern: objects, abstractions, animals, words, floral arrangements, shapes, hearts, food, etc. Draw anything that feels right or passionate for you.

What can I draw my patterns on? There are no rules; a pattern can look great on anything! You can draw patterns on most objects in this book: in your notebook—on your shoes, on a pillow, on the wall, on a skateboard, on an old object, on your cell phone case, on a gift package, or just draw it on a piece of paper and frame it.

Anything else? Repeat. Repeat. Repeat. Repeat.

To your left is a bunch of different pattern studies I did as a collaboration with the amazing shoe designer Paul Andrew in New York City.

WORDS of WISDOM

Whether it's Steve Jobs, Oscar Wilde, Picasso, Abraham Lincoln, or Winnie the Pooh, we're all inspired by great words from inspirational people. The Internet and social-media sites like Pinterest, Instagram, and Tumblr have made images of quotes even more popular these days. I frequently update my Instagram with my own maxims or phrases, all hand-lettered with Sharpie. I usually get tons of great responses from others because of the universality of it all. We all share similar stories and feel similar ways at times, and writing down how you feel is a way to connect with others.

So the next time you hear or read something that inspires you, or if you think of something you like to write, then write it down and make an illustration out of it—and then share it! You never know who you could inspire in return.

Jessica Walsh
She loves writing sayings and including them in her lectures, as well as sharing them on Instagram.

Jessica Walsh
New York, New York

Jessica Walsh is a designer, illustrator, art director, and partner at Sagmeister & Walsh in New York City. She is also my co-conspirator on personal projects such as "40 Days of Dating," an experiment where we "dated" each other for forty days. Jessica loves quotes, and she uses them in lectures she gives across the world. You can see the rest of her work here: sagmeisterwalsh.com.

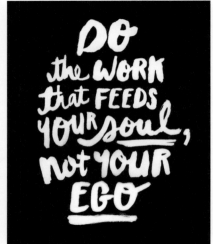

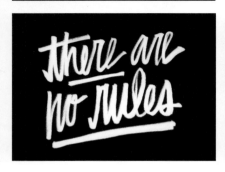

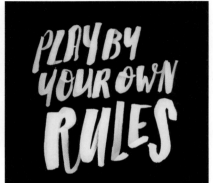

Jessica uses a wide array of Sharpie markers when writing out her sayings or her favorite quotes. I love the simplicity and honesty of it.

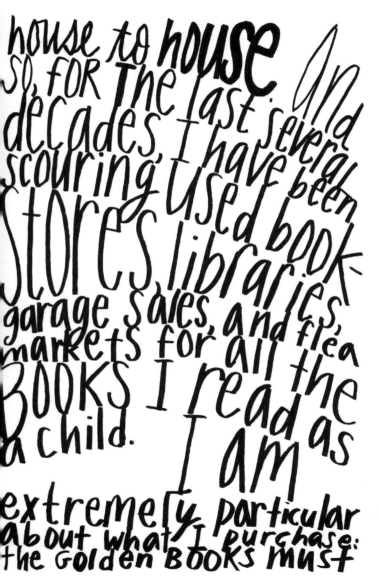

house to house so, for the last several decades, I have been scouring, used book stores, libraries, garage sales, and flea markets for all the BOOKS I read as a child. I am extremely particular about what I purchase: the Golden BOOKS must

Debbie Millman
New York, New York

Debbie Millman is a writer, educator, artist, and designer who is perhaps best known for her great podcast called *Design Matters*. She is president of design at Sterling Brands, working with brands such as Pepsi, Colgate, Nestlé, and Campbell's. She has authored several books, and chairs the master's in branding program at the School of Visual Arts. Simply put, she does it all. I love her hand-lettered essay in her wonderful book, *Look Both Ways*. Check out her work here: debbiemillman.com.

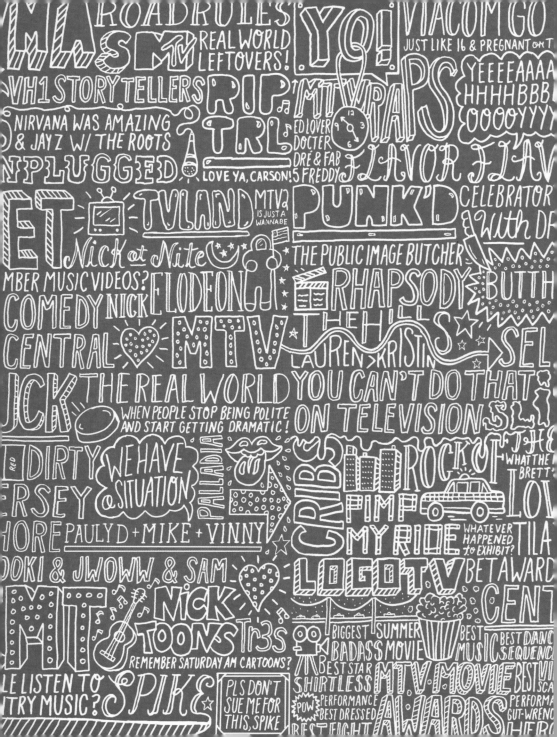

WRITE your OWN WORDS

What are you going to write?

You can write anything! Do you want to pull an old quote or a favorite saying that you love? Do you want to use a piece of your own writing? Maybe you can just write a declarative statement like, "I love you" or, "Smile more." Anything goes.

What kind of style should you use?

I suggest you practice lots of different styles and find ones that you're comfortable with. Don't forget the tracing-paper refining section. This is one task that can come in handy when refining your writing/hand lettering. I always use tracing paper to refine my hand lettering, over and over and over. However, if the quote is good, it has nothing to do with a style. Many of the phrases that I write are all about the content, not about a style.

What can I do with this?

You can frame it and put it in your home. You can frame it (or not) and give it to a loved one as a gift. You can simply post it on Instagram or Facebook and share your sentiments with the world like I do. You can just keep it in your notebook as you practice on your lettering.

What Sharpie should you use?

You can write with any kind of Sharpie. Use the fine-point for a more consistent ink flow. However, if you want a variety with your stroke thickness, then use the Brush Tip (my personal favorite). Maybe you want your words to be thick and broad—then you can use a Paint Marker.

Here is a piece I created for Viacom and MTV that's wallpaper in their offices in New York City. They let me author it all, so it's a good thing that I was already a pop culture junkie.

RETHINK

How do we take the expected and make it unexpected? How do we turn the ordinary into something spectacular? Sometimes, all it takes is an old piece of wood, a boring tennis shoe, a flower vase, or a drinking glass, and *voilà*! Suddenly, you give this old thing some character and personality that it lacked. I often find stuff lying around my apartment and draw all over it to keep it from looking so boring and mundane. My mom used to draw on my old lunch bags, too. Admittedly, I also like to multitask by taking existing stuff that I own, draw on it, and give it to people as gifts. They get an item and a piece of artwork at the same time.

Finally, if you're looking to rethink an old item, you can always go to thrift shops, junkyards, or dollar stores and look for stuff that you could draw on. Really, everything you see is a possibility.

Mikey Burton
Chicago, Illinois

Mikey Burton is a designer and illustrator working for himself. He also has a great beard. His clients include Converse, ESPN, Target, the *New York Times*, *Time* magazine, and *Esquire*, among others. Burton earned a master's degree from the great Kent State University in Ohio, my home state. I once painted a mural with Mikey in a bathroom for the Art Directors Club in New York and we sweated a lot. Check out his work here: mikeyburton.com.

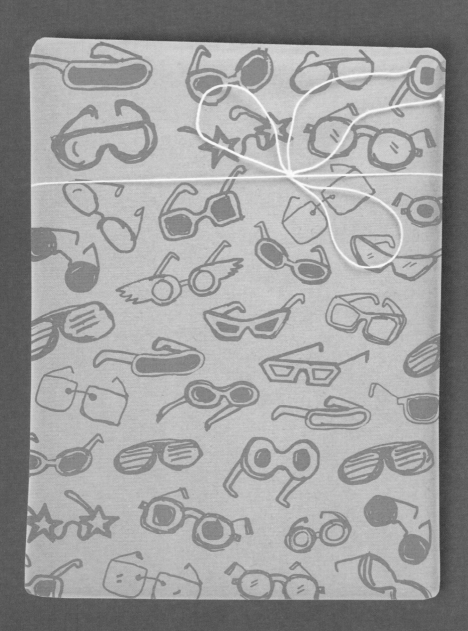

GIFT WRAP

Are you buying gifts for someone on their birthday or for a holiday? Want to go the extra distance and impress someone you care about? Well, who says you have to go out and buy boring wrapping paper for your gift? Get creative instead, and make your own custom wrapping paper. All it takes is some brown paper that you can buy at a craft store (or use a brown grocery bag!) and a Sharpie, and you've got yourself a whole slew of possibilities.

You can take all kinds of ideas we've discussed so far and apply it to the gift wrap: doodle all over the gift; make a pattern on the gift with shapes or words; make some marks; or just write the person's name really big on the gift. Whatever you do, it will surely make a big impression on the person you give it to. However, if you need some help tying nice bows, don't ask me— search online for that!

Try drawing a fun pattern on your wrapping paper! Depending on the occasion, you can pick a theme. Here, I drew sunglasses for a summer birthday gift.

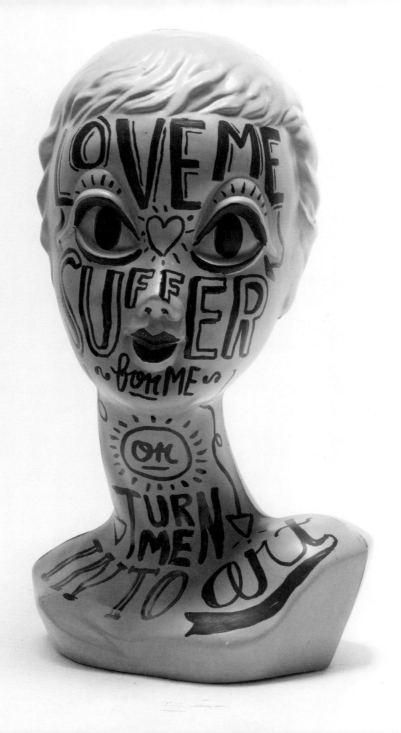

WORDS on OBJECTS

Recently, I started a side project with my good friend and creative partner, Jessica Walsh, as a way to breathe new life into old objects. Why? Well, we all use so much stuff. We collect stuff, buy stuff, steal stuff, trade stuff, and then throw stuff away. So what happens with all this old stuff? Is there a life after it leaves our hands? Stuff winds up in our garbage, on our streets, in our landfills, and in our junk shops. We felt bad for this abandoned and rejected stuff, so we decided to rescue these objects and breathe new life by spray-painting them and giving them a voice with words. We want to turn old stuff into new stuff and give it a second chance.

And the great thing about this is that anyone can do this. So, the next time you're at a thrift shop or see old stuff lying around your house, take it in the garage, put some spray-paint to it, and Sharpie your favorite quote or phrase on it.

Jessica and I took a great quote by Henry Miller and applied it all over this mannequin.

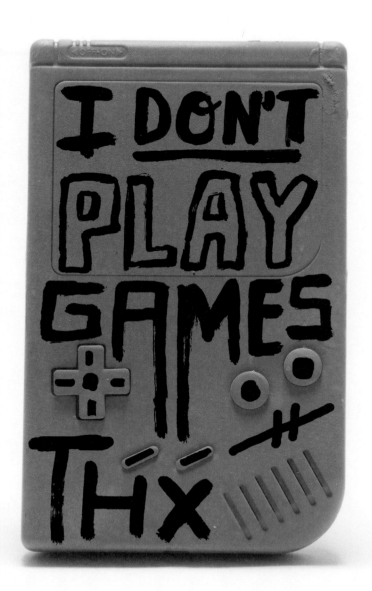

Quotes on Sh*t

Here's more from my personal project with Jessica Walsh—all done with old objects, spray-paint, and a Sharpie. If you want to submit your old, unwanted stuff to us so we can make it new again, please email us at quotesonshit@gmail.com. And check out the entire site at quotesonshit.tumblr.com.

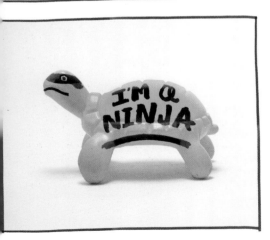

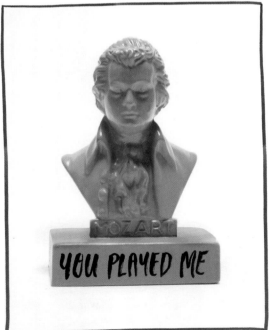

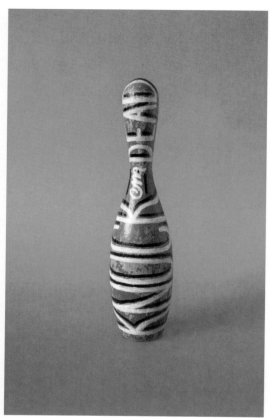

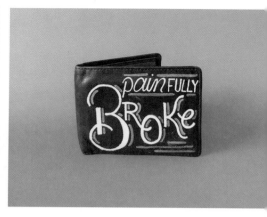

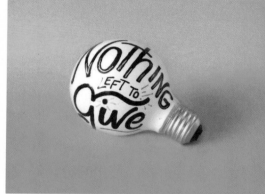

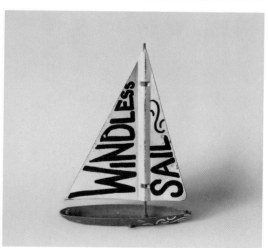

Adé Hogue
Chicago, Illinois

Adé Hogue is a Chicago-based graphic designer and illustrator. He started a personal project called "Letter on Me" where he hand letters sayings on objects that people send to him. I'm a big fan. Check out the project here: letteronme.com.

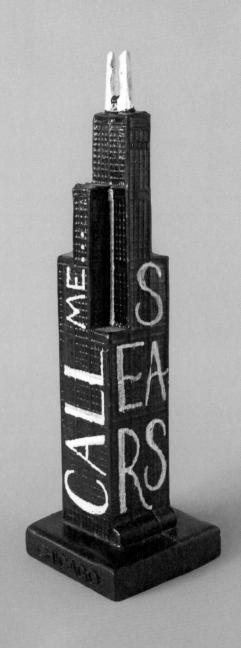

MAKE your OWN OBJECTS

Where can you get an object?

You can buy an old object at a thrift or junk shop. You can take an object you already own in your house or an old item stored away in your attic or your garage. You can grab an object off the street or in the trash (I suggest being careful, though. You don't want bed bugs!). You could also look for objects at garage sales.

What Sharpie should you use?

It really depends on the size of your object. If it's a relatively small object, then you'll need to use something more standard like a Fine-Point Sharpie. If you're working on an object that's a bit larger, then I suggest Sharpie Paint Markers because they adhere well and lay on thick.

What should you write?

You can write anything you want! However, I think it works best when you think about the actual object you're writing on. Can fun puns or idioms relate to your object? Can you make a statement or commentary regarding it? Maybe you can use a fun buzzword? The options are endless.

What should you do with the object?

Once the object has been painted and the words have been applied, you have a finished piece that can be a great gift for someone. You could also display it in your house. Even better, make a series of these custom objects and give them away. Just be sure to take photos!

Here's a little step-by-step of how we achieve this look on a random object.

1" x 2"
(2.5 x 5 cm)

ITSY-BITSY

Drawing on mini-frames is a personal favorite of mine, and something I've been doing for years. You can buy these at most art supply stores, and they are a simple and great gift to give to friends. I'm always surprised and delighted to see how much a little handmade gift like this can be such a great way to make a friend or a loved one smile. When I lived in San Francisco, I would visit my friends in New York a lot, and I began giving little frames as gifts. On one four-day trip, I gave out about twenty of them to my friends.

I would customize each one to make it unique for that person. Whether it was an inside joke between us, something they personally loved, something that represents a gift, or just simply writing their name on the frame, it was relatively easy and rewarding way to make your work a gift for a loved one. You should try it as well!

MAKE *your* OWN MINI FRAMES

Where can you get these?

They sell these mini frames at most art and craft stores, and you can buy them online at most places including Michaels and Amazon. They come in different sizes like 1" x 1" (2.5 x 2.5 cm), 1" x 2" (2.5 x 5 cm), and 2" x 2" (5 x 5 cm).

What color is your canvas?

You can leave the frame white and draw with a black Sharpie or a colored Sharpie. You can buy black canvas frames, too, and then draw on them with white Sharpie Paint Markers. You could also paint or spray-paint a white canvas frame in any color you want before drawing on it with a Sharpie.

What Sharpie should you use?

Because of the small size, I usually just use the Fine-Point Sharpie. I find that anything too thick doesn't work for detail, and anything too thin doesn't hold enough presence on the frame. But feel free to try anything you like or feel inspired by!

What should you draw?

I've always enjoyed giving these as gifts, and I usually draw something unique about the person I'm giving it to. Sometimes, I hand letter their name or draw an inside joke between us or their favorite object.

What can you do with them?

You can lean them against your books, hang them on the wall with a nail, or put a magnet on the back and hang them on your refrigerator.

EMBELLISH a PHOTO

A great design teacher I had at the School of Visual Arts in New York City, James Victore, once gave us a project called "Tell the Truth." The gist of this assignment was to find an ad in a magazine or a newspaper—something that we deemed dishonest—and draw on top of it to redefine the image or cause someone to look at it from a different perspective. Personally, this was a tremendous assignment for me that I have since used in different ways throughout my career, including my editorial illustration work for publications such as the *New York Times*, the *New Yorker*, and *Time* magazine.

How do we take the expected and make it unexpected? How do we take a cliché and flip it? These are fundamental questions I ask myself at the start of every project, and I believe it's the foundation for all memorable work. Altering an existing image with a Sharpie marker is a great way to be witty, humorous, and to essentially "tell the truth."

This is a photo illustration I did for the *New York Times* Op-Ed section. Art direction by Matt Dorfman.

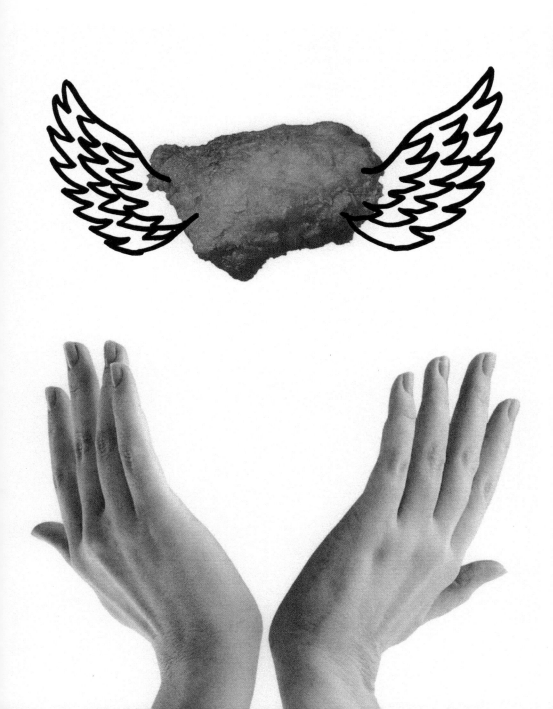

An illustration for the *New York Times Book Review* about the self-centeredness of writers and memoirs. Art direction by Nicholas Blechman.

Memoir

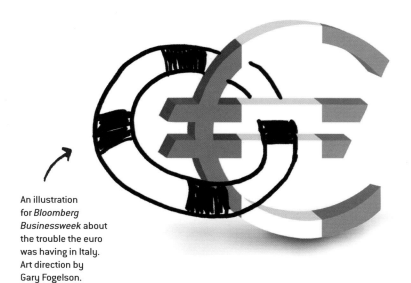

An illustration for *Bloomberg Businessweek* about the trouble the euro was having in Italy. Art direction by Gary Fogelson.

An illustration for a book called *Wired Humanity* about how Mother Nature can have ultimate sustainability.

An illustration for *Time* about the financial crisis on Wall Street a couple of years ago. Art direction by Nai Lee Lum.

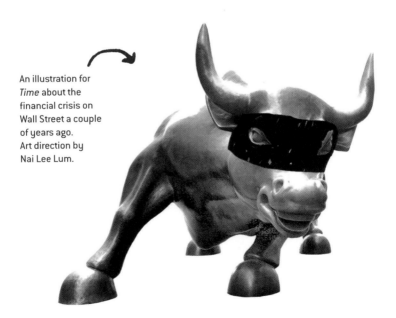

POST-ITS

Everyone has probably used or seen a Post-it note in their life, but just in case you've been under a rock, Post-it notes are small pieces of paper with a strip of glue on the back, used for temporarily attaching notes to documents and other surfaces. Post-its are good for reminding us of our daily tasks, and they're also used as personal notes we leave ourselves and for our loved ones. You can leave a fun note for your family when you leave in the morning, or maybe leave a message to a colleague at the end of the day, or simply make a doodle on a Post-it and take a picture of it to send to a friend by text or email.

Post-its are also great for creating art. One note tells a moment, but many Post-its together can tell an entire story, as you'll see on the following spread. So don't get too stuck on your ideas, just get it out and see if it "sticks" to the wall!

Arthur Jones
Los Angeles, California

Arthur Jones is a designer, illustrator, and animator living in Los Angeles, California. He graduated from the Rhode Island School of Design. He was awarded a MacDowell Colony residency in 2009. Check out his work here: byarthurjones.com.

Post-it Note Series

While working at his boring day job, Arthur Jones started writing stories in Microsoft Excel and illustrating them on Post-it notes. Eventually, he started reading these work stories in public—at bars, bookstores, and art galleries. To accompany his performances, he projected a slideshow of his Post-it note drawings behind him. Thereafter, he expanded that into the "Post-it Note Reading Series," where both established authors and non-writers could present stories over a backdrop of his Post-it drawings. In 2011, he published a book called *Post-it Note Diaries*, which is an extension of the "Reading Series."

STICK your ART

What kind of Post-its should you buy?

Post-its are sold in most drugstores and office supply stores around the world. The traditional color is yellow, as seen to your right, but usually you can buy them in an assortment of colors such as red, orange, pink, blue, green, and purple. You can also buy them in various sizes such as: 1½" x 2" (3.8 x 5 cm), 2" x 2" (5 x 5 cm), ½" x 1" (1.3 x 2.5 cm), 3" x 3" (7.6 x 7.6 cm), and as big as 6" x 8" (15.2 x 20.3 cm).

What Sharpie should you use?

I love to use metallic Sharpies on different colored Post-its. Other than that, I'd stick to anything that isn't too thick. Since Post-its are so thin, a lot of the markers, like a Brush Tip or a Paint Marker, will bleed through.

What should you draw?

Personally, I love when Post-its are used a bit more functionally. For instance, make a fun note for a colleague or draw your loved one a little something in the morning before you leave. That being said, doodling on Post-its for fun is a great way to come up with new ideas or to just kill time at work.

What can you do with them?

If they're not going to be used as a way to correspond with someone, as I just described, then definitely turn them into art! You could make fifty Post-it note drawings and frame them. I've done this before, and it's a great gift! You could also draw on a bunch and hang them on your wall, like the Peckham Peace Wall in South London, a public art installation of 4,000 Post-it note messages from residents about riots that occurred in 2011. There are many options.

2 CUPS FLOUR
1 CUP SALT
2 CUPS WATER

MIX TOGETHER

ENJOY!

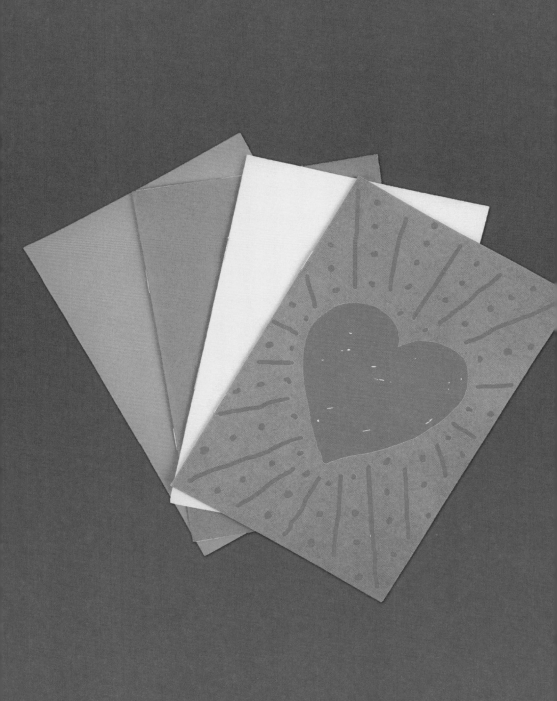

LOVE CARDS

We spend so much time in front of our computers, our phones, and our tablets that we forget how important it is to make something by hand. Sure, we write nice emails and texts to loved ones, give a "like" to someone on social media, or order something for someone online. But how can we honor our relationships a bit more tangibly? What would it mean to make a handmade gift for someone in the digital world?

I like using different colored construction paper to draw on when I give notes to people I care about.

You can make a simple card for a loved one on any occasion. Whether it's Valentine's Day, an anniversary, or birthday, giving a handmade card with a drawing or a note on it is a great way to remind someone just how much you care. Also, because it's a relatively easy process, you can make an abundance of them as a way to show you care even more! I often make little cards as a series for different relatives. Also, it never hurts to make a handmade note for a girl or guy you like!

GIVE SOME LOVE

Who should you make them for?	Cards of affection can be made for anyone in your life that you want to make happy, impress, or show your love to. They can be a great way to bring a smile to someone's face, and really, what is better than that?
What kind of cards do you buy?	The good thing about making cards for someone you love is that it doesn't matter what kind of material you use. Yes, you can buy index cards at a local shop, but you can also use notebook paper or a paper shopping bag you might have in the house. My favorite is to cut up colored construction paper, as you can see on the previous spread.
What should you draw?	As you can see from my cards to the right, sometimes the best stuff is the most simple because it's the most honest. Just write or draw what comes to your mind, and try to do it in a lighthearted, fun way.
What can you do with them?	You can make them and send to someone in the mail (always a fun surprise!); you can give them to someone in person; you can scan or take a picture of it and send it to someone by email (I do this a lot); or you can frame it and give it as a gift.
What kind of Sharpie should you use?	Use any kind of Sharpie you want. If you're using construction paper, you shouldn't have to worry about it bleeding through. I would just consider the size of your cards. If they're small cards then you won't be able to get a lot of detail with a thick tip.

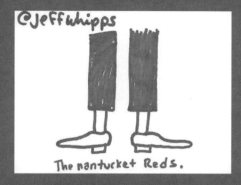

@Jeffwhipps

The nantucket Reds.

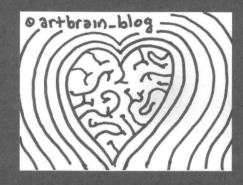

@artbrain_blog

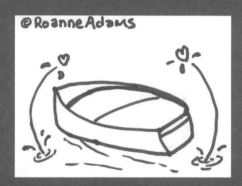

@RoanneAdams

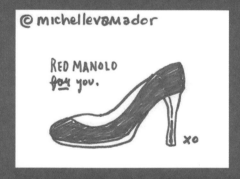

@michellevamador

RED MANOLO
~~for~~ you.

xo

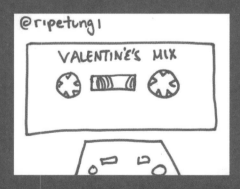

@ripetung1

VALENTINE'S MIX

Valentine Tweet-a-thon

One Valentine's Day, I attempted to draw a unique valentine for every single one of my Twitter followers between the hours of 7 a.m. and 7 p.m. By doing this, I responded to each follower's handle/picture/bio as seen up top. The plan was to draw each one on a 4½" x 5½" (11.4 x 14 cm) pre-cut card, take a picture, and tweet it directly to each follower in real time. At the time, I had 1,150 followers, and I estimated roughly 96 an hour, or approximately 38 seconds for each response. Unfortunately, I was not able to finish all of them, but I did finish close to 600. Check it out here: valentinetweetmarathon.com.

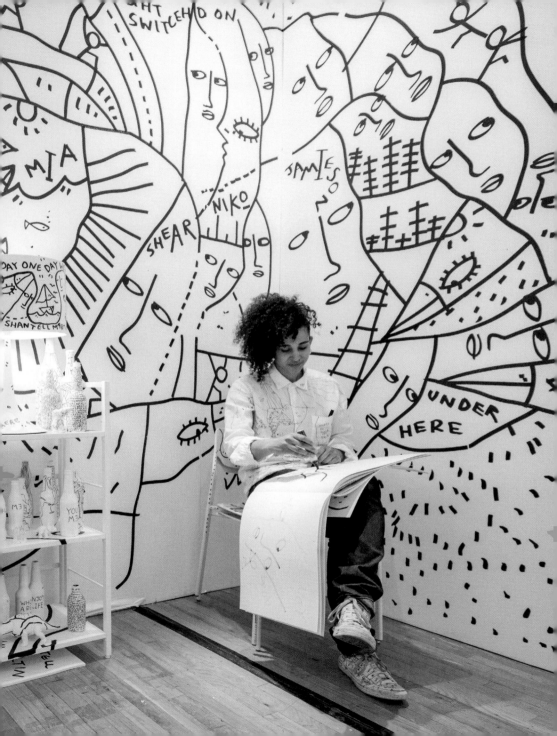

MURALS

There is something about drawing on a wall that makes it immediately compelling, impressive, and sexy. Artists have been creating wall murals and installations since 30,000 BC. From Michelangelo to Diego Rivera to Banksy, we continue to celebrate and be impressed by this large gesture by artists, if nothing but for the sheer audacity and scale. For me, working in a physical space has always been truly exhilarating—both physically and mentally. Seeing the process of how a Sharpie can transform a room, a wall, or a building, from beginning to end, is one of the most rewarding feelings I've had as a creative person in my short career.

You can achieve many effects by drawing on your wall. Whether it's using simple contoured lines or really digging in and creating effects with your markers, you can explore a variety of ways to make your ideas come to life on a large scale.

Shantell Martin
Shantell doesn't waste any opportunity. As her website description proudly says, she "draws on everything."

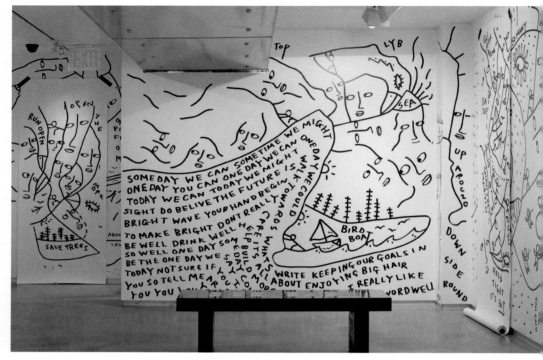

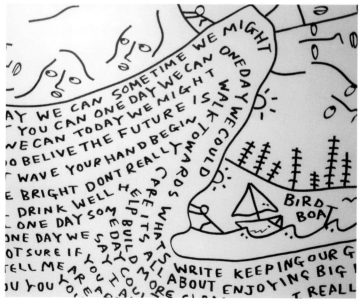

Shantell Martin
New York, New York

Shantell is one of my favorites. She is a British artist best known for her stream-of-consciousness drawings and light projections. She uses Sharpie markers on walls for corporations like MTV and MoMA, as well as her own art shows. Her work is usually black contour drawings flowing from one wall to the other. Check out her work here: shantellmartin.com.

Gemma O'Brien
Sydney, Australia

Gemma is an Australian artist and typographer who creates many jaw-dropping murals all around the world. She works in a variety of styles, sometimes more illustrative or typographic than others, for corporations and publications, as well as personal art shows. She is one of the rare artists who can hand letter in almost any style. Check out more of her work here: jackywinter.com/artists/gemma-obrien.

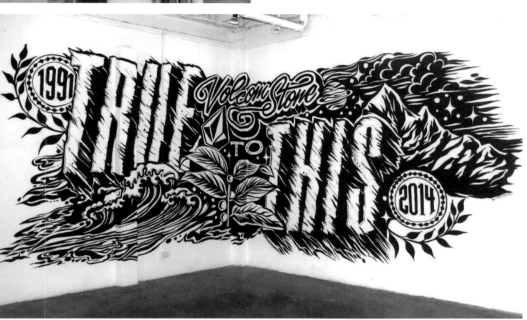

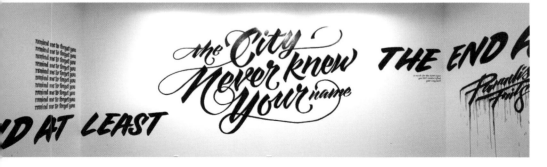

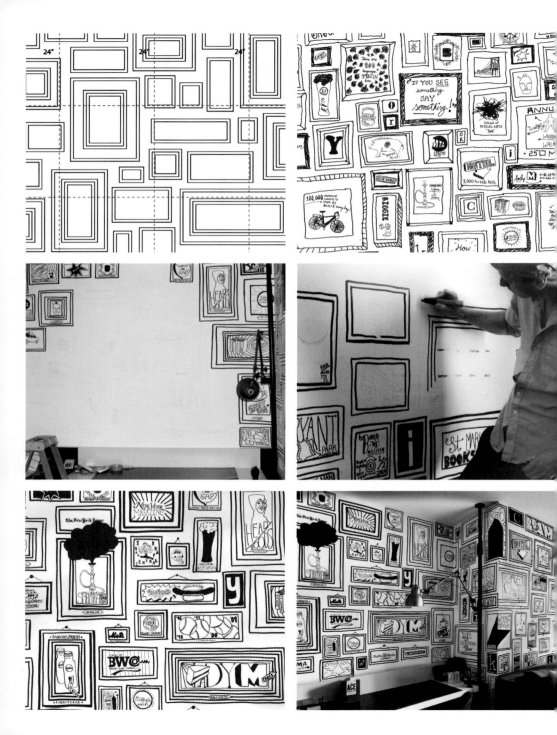

WANT to CREATE A MURAL?

Is your wall ready?

Is your wall inside or outside? Is it a smooth finish? What color is it? Are there holes that you need to fill first? Do you need to paint the wall first? Make sure the wall is exactly what you want before you begin drawing.

What's your plan?

Did you create a sketch first? I have approached all of my murals in different ways: 1. Projecting a paper sketch; 2. Freestyling it right on your wall; 3. Gridding out a sketch proportionally to the size of the wall, as you can see to your left; 4. Pencil sketching on the wall and then going over it with a Sharpie.

What kind of a space is it?

Are you drawing on an entire wall? An entire room? Or are you just drawing on a small section? Is it in your bedroom? Bathroom? Office space? Think about the scale and the relationship the mural has with its surroundings.

What will you draw?

Consider things you like or that are important to you. Perhaps you write out lyrics to your favorite song? Maybe you draw a map of your country? Maybe it's all about your family? Make lists of what you want to draw first.

What Sharpie should you use?

I'd recommend using a Sharpie Paint Marker for a wall mural like this. It goes on thick and you can choose different size tips. Are you painting the wall first? Consider the color of the wall when choosing the paint marker, too. For instance, a white paint marker looks killer on a black wall.

Here's a step-by-step process for the mural I created for the Ace Hotel in New York City, including an early sketch and a wall grid I made first.

DINNERWARE

Throwing a dinner party soon? Want to avoid having the same old usual dinner? Maybe you want to have some family fun? Well, get creative for your next party! Your family and guests will love it, and there are plenty of ways you can spice things up for dinner by simply adding some creative fun. Who knew Sharpie could go so well with dinner?

Make a fun afternoon with the family, or a night with your friends, and make custom dinnerware with Sharpie markers. You can always buy cheap plates and glasses from the thrift store and write everyone's name on them or create fun name tags for everyone who is sitting at the table. My friend Chris folds paper and writes Pantone colors on them, then he wraps it around the napkins. For your immediate family, you can write names on the plates like Mom, Dad, son's name, daughter's name, Grandma, and even make one for the dog bowl.

Tato Tortosa
This awesome plate was created by Tato, an illustrator and designer based in Buenos Aires, Argentina. Check out his work here: behance.net/tatotortosa.

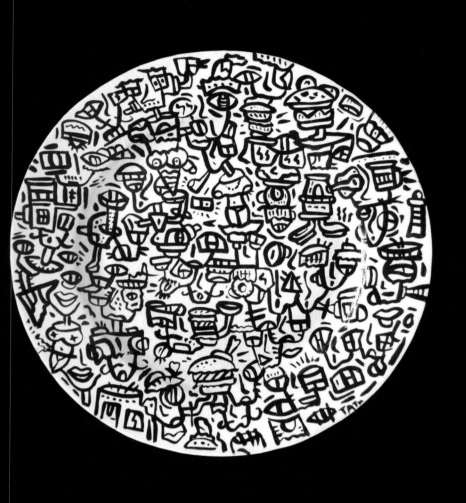

Example 1:
Draw an object!

Example 2:
Draw a pattern!

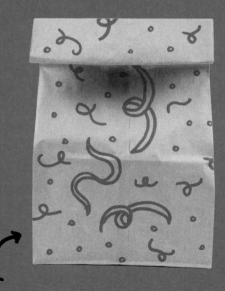

Example 3:
Doodle and doodle!

Example 4:
Make fun marks!

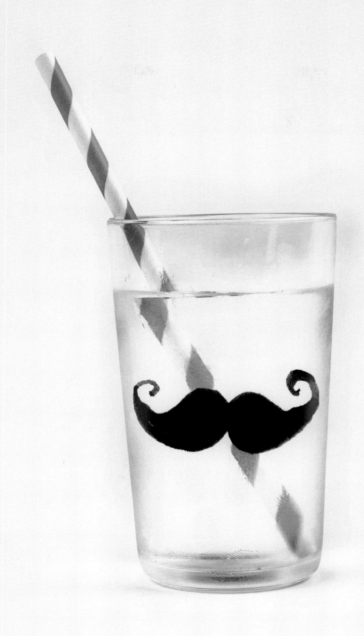

THROW a DINNER

Who should you invite?

You can throw a dinner party with friends, family, couples, or a loved one. Perhaps it's for a holiday? Think about the theme of your drawings and decorations you make.

What should you draw?

Depending on who's coming over for dinner, you can create custom tags or glasses that you write their names on. If you have kids, you can make a fun workshop out of it where they can make their own art on the dinnerware. Finally, if you're having dinner for a particular holiday, then you can decorate the dinnerware, depending on the theme.

What should you draw on?

If you don't want to draw on your good set of dinner plates, you can buy cheap dinner plates at a thrift store just for the specific party you're having. They shouldn't cost more than a couple of dollars. Also, if you're cooking outdoors you can decorate paper plates, napkins, and plastic cups! Be sure to avoid decorating any surfaces that could come in contact with food, drink, or your mouth (if you're decorating a glass or a cup). If you want to draw all over a plate, you can display it decoratively, or use it as a charger or platter underneath a clear glass plate.

What Sharpie should you use?

Sharpie Paint Markers will leave the best mark on any dinnerware, particularly glass or ceramic. But it's really up to you. I suggest practicing on some glasses or plates first.

Anything else?

Don't forget that these could be hung on the wall as art, too. I often see hand-painted plates sold at a variety of home life stores.

If you're having a BBQ, decorate your paper plates to use as fun accents.

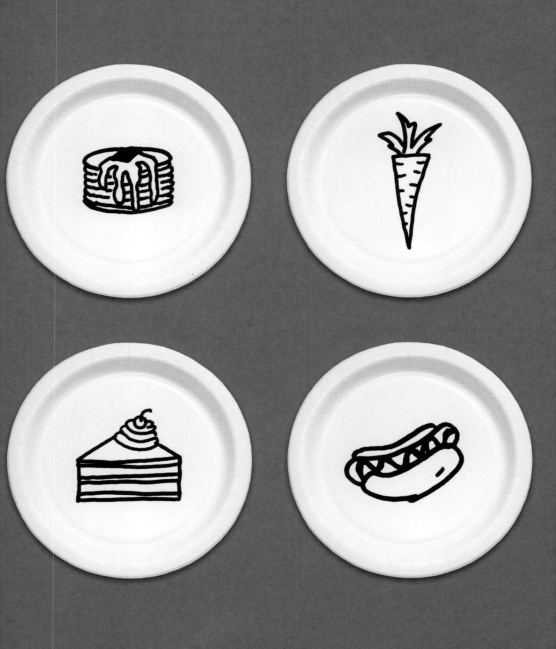

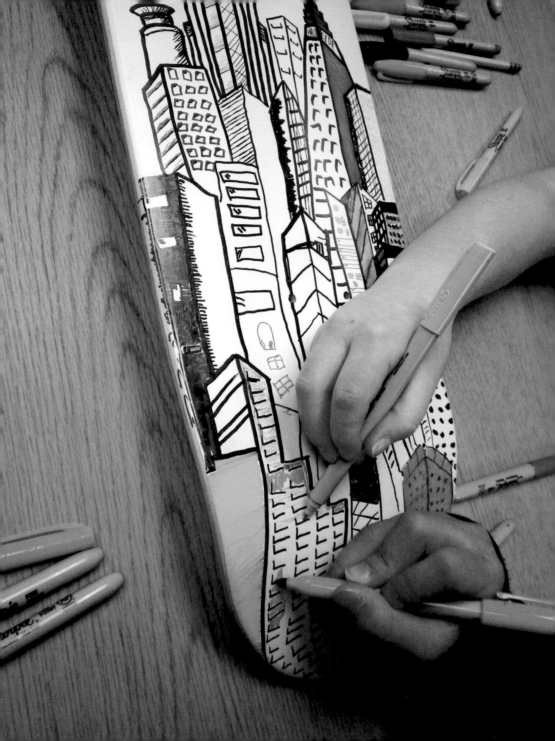

SKATEBOARDS

Drawing and painting on skateboards has become increasingly popular over the years. It can be a great way to customize a skateboard that you're currently riding or one that you simply want to hang on your wall as art. Websites like Zazzle or BoardPusher sell boards already drawn on, and they also allow you to decorate your own board with a digital file to showcase your many talents.

However, nothing is better than actually drawing on your own board with a Sharpie. You could draw a word or your name, decorate it with a pattern, or even redefine the actual shape by making it look like a Popsicle or a Band-Aid. Many of the techniques we've talked about can work for whatever you decide on. No matter what, we'll show you some fun skateboard inspiration in this section to get your wheels turning.

Students at Rivard Art Education have fun drawing on skateboards with Sharpie markers.

Tom O'Toole
Tom is a really great designer and illustrator based in Portland, Oregon. Check out his work here: ibrontosaurus.com.

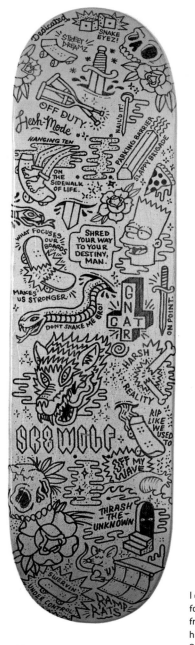

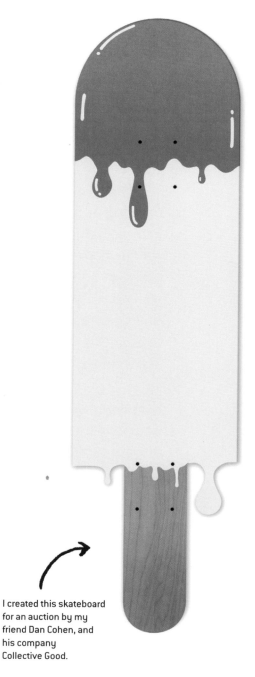

I created this skateboard for an auction by my friend Dan Cohen, and his company Collective Good.

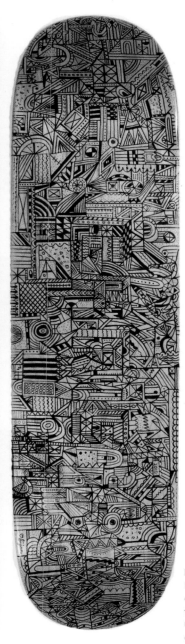

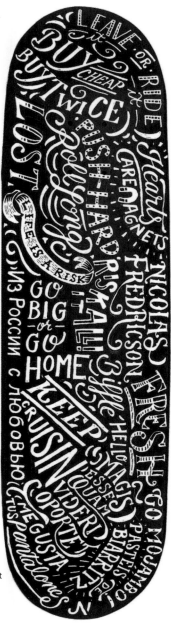

João Neves
This lovely board
was created by
João Neves, a
graphic designer
based in Lisbon,
Portugal. See
his work here:
behance.net/
nevesman.

Bijan Berahimi
Bijan is a really great
designer who works
for Nike in Portland,
Oregon. Check
out his work here:
bijanberahimi.com.

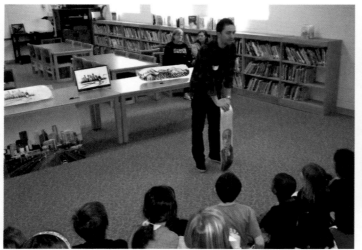

Mark Rivard
Minneapolis, Minnesota

Mark Rivard is a fine artist, writer, and educator who runs a private art gallery and studio space in Minneapolis, Minnesota. A couple of years ago, he launched an art education program called Rivard Art Education, which is a unique program that focuses on motivating and inspiring young minds through the use of art on skateboards. Check out more here: rivardarteducation.com.

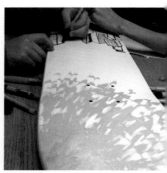

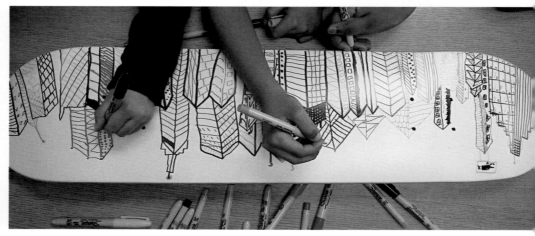

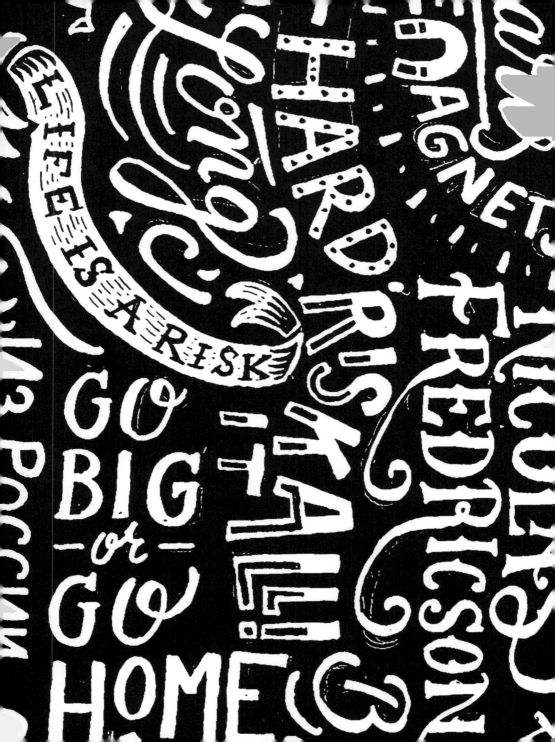

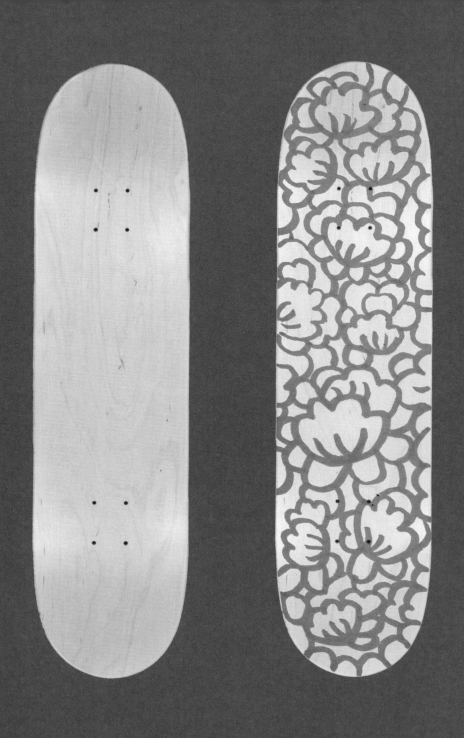

DRAW on A BOARD

Where should you buy a board?

You can buy a skateboard at any local skate shop in your city or at any sporting goods or department store. If you're just buying them to do art, then you can order blank ones online.

How do you prep your skateboard?

Are you buying a blank one? Is it painted already? Do you want to paint it? You should consider all of this before you draw on it. Also, it may be a good idea to seal the skateboard after you're done drawing on it. A clear lacquer finish works well. Put a matte finish on so it's not shiny.

What should you draw?

You could use many of the exercises we've discussed in this book and apply them to a skateboard, such as patterns, doodles, words, or even "play" and mark making. However, make sure you sketch it out first! If you can, I'd take a picture of it and print the picture out and do some light sketching over it with tracing paper as we discussed earlier in the refining section.

What kind of Sharpie should you use?

I prefer using different Sharpie Paint Markers for this since there is so much space to cover. However, some people, such as Mark Rivard and his students (shown page 98), tediously use the fine-point markers to cover their boards. Use what feels comfortable to you.

What else?

Are you good with a saw? Do you know someone who is? While this is a bit advanced, you could always cut your skateboard in a shape (see my popsicle board on page 96) and then draw accordingly.

Use a Sharpie Paint Marker to make a pattern on your skateboard.

ENVELOPES

My grandmother, Ann Caywood Brown, is an artist who has been a wonderful inspiration for me my entire life, both professionally and personally. She loves to send all her grandchildren beautiful handwritten notes and envelopes made with love and creativity. However, she's also eighty years old, so this comes more naturally for her. In today's digital age, people from my generation seldom send personal notes anymore. We'd rather text, tweet, or email a message than take time to make a note or an envelope with thoughtfulness and send it off.

Well, this is something that my very talented friend Erik Marinovich considered when he started sending off beautiful envelopes in the mail. He wanted to take a traditional old-school way of communication and turn it into art. What you will see here is part of his wonderful personal project called "Do Not Open."

Erik Marinovich
Erik's hand-lettered envelopes, made with Sharpie Paint Markers, are part of his amazing personal project, "Do Not Open."

FUZCO!

95 — Cannon St. —

CHARLESTON SC 29403

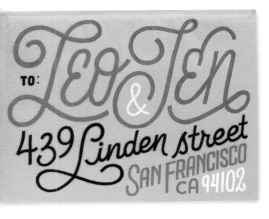

TO: Leo & Jen

439 Linden street

SAN FRANCISCO CA 94102

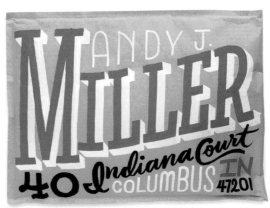

ANDY J. MILLER

40 Indiana Court

COLUMBUS IN 47201

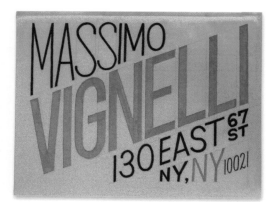

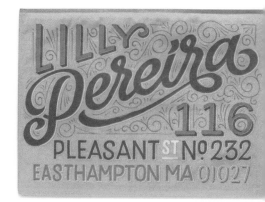

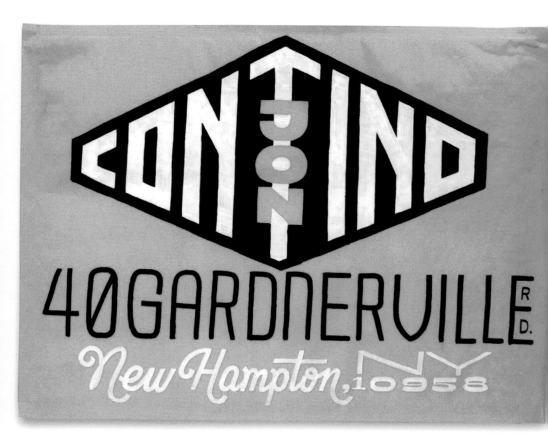

Erik Marinovich
San Francisco, California

Erik Marinovich is a letterer and designer based in San Francisco. He is one of the cofounders of Friends of Type, a collective that features original typographic design and lettering. He has worked for clients such as the *New York Times*, *Wired*, GAP, and Nike. "Do Not Open" is a personal project meant to revisit the old feelings you'd get back when we had pen pals. Check out his work at erikmarinovich.com, and see all the beautiful envelopes at: donotopen.it/envelopes.

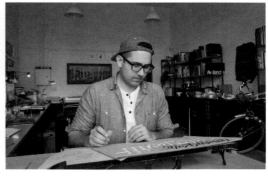

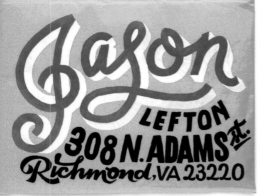

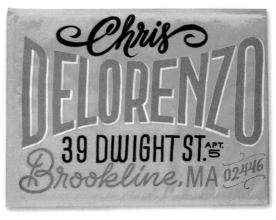

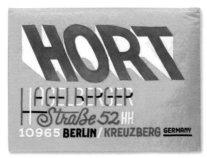

SEND your OWN

What kind of envelope to use?

There are tons of envelopes you can buy and draw on. Here in North America, there are several styles, including A-style, baronial, booklet, catalog, commercial, office, packing list, square, and window, to name some. Obviously, your decision will depend on what needs to go inside.

What should you draw?

My grandmother puts little hearts on envelopes. Sometimes I draw skulls on envelopes. I'll also draw the person's name very flamboyantly. And you've just seen how Erik transforms a catalog envelope with the person's address. You can also draw on the inside of the envelopes as a nice surprise. Really, anything goes!

Who should you send it to?

Send it to someone who you think would really appreciate it. Send it to your mom, your children, your significant other, or that boy or girl that you're trying to impress. In today's digital age, there's nothing like receiving a note in the mail. Decorating an envelope is a great cherry on top. That level of detail and attention will surely make a great impression.

What Sharpie marker should you use?

It all depends on what kind of envelope you're using. If your envelope is thicker, like a catalog envelope or an A-style, then you could use anything, including a thick Sharpie Paint Marker. However, if you're sending a commercial regular letter-size envelope, I would avoid using a marker that's too thick, since some markers might bleed through.

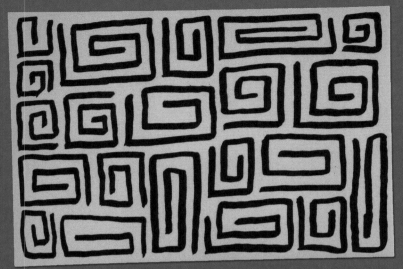

Example 1:
Try making a fun pattern on your envelope.

Example 2:
You could write their name in a fun and creative way.

CONTRIBUTORS

JULIA ROTHMAN
Brooklyn, New York
juliarothman.com

MARK RIVARD
Minneapolis, Minnesota
rivardarteducation.com

ADÉ HOGUE
Chicago, Illinois
adehogue.com

MIREIA RUIZ
Barcelona, Spain
mireiaruiz.com

BIJAN BERAHIMI
Los Angeles, California
bijanberahimi.com

KATE BINGAMAN-BURT
Portland, Oregon
katebingamanburt.com

ARTHUR JONES
Los Angeles, California
byarthurjones.com

CAROLYN HINKSON-JENKINS
New York, New York
sva.edu

DANIEL BLACKMAN
New York, New York
danblackman.com

CAROLYN SEWELL
Washington, DC
carolynsewell.com

JESSICA WALSH
New York, New York
sagmeisterwalsh.com

YANN LE DLUZ
Paris, France
yannzuldel.com

MATTI VANDERSEE
Heredia, Costa Rica
behance.net/vndlzr

TOM O'TOOLE
Portland, Oregon
ibrontosaurus.com

MIKEY BURTON
Chicago, Illinois
mikeyburton.com

SHANTELL MARTIN
London, United Kingdom
shantellmartin.com

JOÃO NEVES
Lisbon, Portugal
behance.net/nevesman

JEN MUSSARI
Brooklyn, New York
jenmussari.com

DEBBIE MILLMAN
New York, New York
debbiemillman.com

TATO TORTOSA
Buenos Aires, Argentina
behance.net/tatotortosa

ERIK MARINOVICH
San Francisco, California
erikmarinovich.com

GEMMA O'BRIEN
Sydney, Australia
jackywinter.com/artists/gemma-obrien

THE WORK YOU OUGHT TO BE DOING IS THE WORK YOU SHOULD BE DOING.

THANK YOU

ARTISTS

I want to thank all the insanely talented contributing artists for letting me high-light them and their gorgeous work in this book. I'm extremely lucky to be in your company, and even luckier to call some of you friends. I also realize that I highlighted more women than men—10 women to 4 men—and that happened for a couple of reasons: I'm currently more inspired by the work and risk taking by the women in my profession from all around the world; and for far too long, without much regard, extremely talented women have been overshadowed in industry conferences, awards, and blogs.

FRIENDS

Huge thanks to my good friend and an amazing designer, Dan Blackman, for co-designing this book with me, as well as photographing all the work. We had way too much fun on Monday nights at the studio in the East Village drinking beer, telling dirty jokes, and watching jazz down the street.

TEACHERS

To all my teachers and mentors that I had at the School of Visual Arts in New York City, and Cuyahoga Community College in Cleveland, Ohio: Your encouragment inspired me more than you know. Now that I teach at SVA, I always tell my students, "Don't worry about what you want to do as much as who you want to work for."

BIO

Timothy Goodman is a designer, illustrator, art director, and content creator based in New York City. His clients include Airbnb, Google, Ford, J.Crew, Nike, *The New York Times*, and *The New Yorker*. He has received awards from most major design and illustration publications, including the ADC Young Guns Award, American Illustration, and *Print* magazine's New Visual Artist. He teaches graphic design at the School of Visual Arts in NYC and spends a significant amount of time on personal projects, such as *"40 Days of Dating,"* which became a book, and the film rights were optioned to Warner Bros. This is his second book.

MAKERS

And finally, I want to thank everyone out there who's making stuff, trying to make stuff, or helping and encouraging others to make stuff, regardless of your experience and qualifications. You're all awesome, and we need you.

FOLLOW TIM ON

TWITTER
@timothyogoodman

INSTAGRAM
@timothygoodman

WORK
tgoodman.com

HELLO!
THIS IS A
SKETCHBOOK
FOR
~~MARKERS.~~
SHARPIE

WHAT SHARPIE SHOULD YOU USE?

No matter what kind you use or
how you use it, everything is begging
for your imagination to run wild.

(see page 8)

Like athletes,
creative people
need to loosen up
and stretch before
the big game.
(see page 20)

Jot down the relaxation
techniques that work
for you as a creative.

Different strokes … See how different lettering techniques affect your perception of the same word in different languages. Create your own letter design for the word "play." Here I've used an elaborate script. See what you can do.

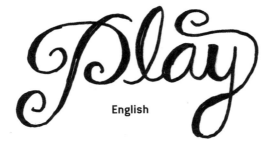

English

What is a scribble, anyway?
" ... to write or draw
something carelessly or
hurriedly in a way that
makes it difficult to read."

The Aggressive

SCRIBBLE HERE!

Write a love note to someone you care about.
(see page 79)

You can use your Sharpie markers on almost any kind of surface—from paper and canvas to fabric, paper, glass or plastic. Why not practice putting your personal mark on your cell phone case?

Here's Wikipedia's definition of what a doodle is: "An unfocused or unconscious drawing made while a person's attention is otherwise occupied. Doodles are simple drawings that can have concrete representational meaning or may just be abstract shapes."

Make this your go-to page to doodle and jumpstart your creative process. Have fun!
(see page 36)

Different strokes ... See how different lettering techniques affect your perception of the same word in different languages. Create your own letter design for the word "play." I used a slab serif — see what you can come up with.

Portuguese

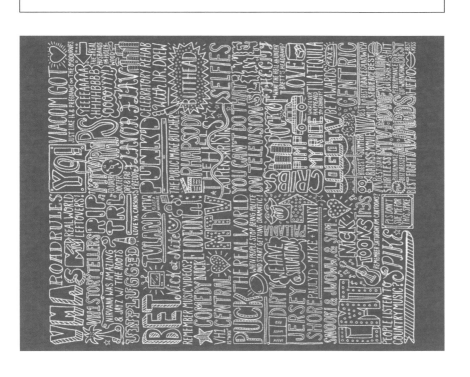

Create a wallpaper pattern for a cool space.
This one was done for MTV's New York office!

(see page 39)

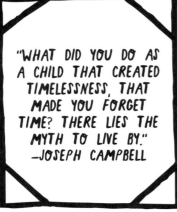

"WHAT DID YOU DO AS A CHILD THAT CREATED TIMELESSNESS, THAT MADE YOU FORGET TIME? THERE LIES THE MYTH TO LIVE BY."
—JOSEPH CAMPBELL

Whether it's Steve Jobs, Oscar Wilde, Picasso, Abraham Lincoln, or Winnie the Pooh, we're all inspired by great words from inspirational people. Illustrate a quote from someone that you admire and gain inspiration from.

(see page 44)

Draw your own Post-it note series to
tell a simple story about your life.
(see page 77)

Embellish this photo with Sharpie drawing techniques to make it funny, functional, or to take it in a completely different direction.

(see page 68)

Swedish

Different strokes ...
See how different
lettering techniques
affect your perception
of the same word in
different languages.
Create your own
letter design for the
word "play." This is a
dimensional typeface.
What will you use?

Sketch your own original wrapping paper.
(see page 55)

Scribble ... it can be more
therapeutic than fine art.

The Traditional

SCRIBBLE HERE!

Why not decorate this sporty car with your Sharpie markers? It will be good practice before you do the real thing! *(see page 57)*

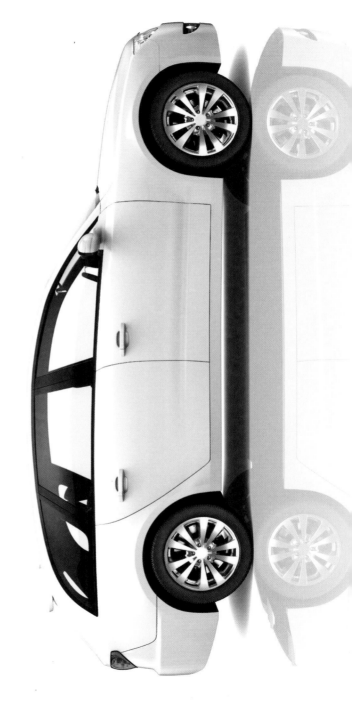

Make some mini frame—size art in these cool frames. You can buy the easels for displaying at a craft store, or better yet, make your own!
(see page 65)

I find it increasingly important for me to carry Sharpie markers and my notebook with me whenever I'm out, in case any ideas come to mind.

Make a doodle of your favorite place to draw.
(see page 20)

Make a sketch that
illustrates your love
for someone.
(see page 80)

Design your own
place setting
of cutting-edge
picnic ware.
(see page 88)

French

Different strokes ...
See how different
lettering techniques
affect your perception
of the same word in
different languages.
Create your own
letter design for the
word "play." I created
a novelty typeface.
What can you design?

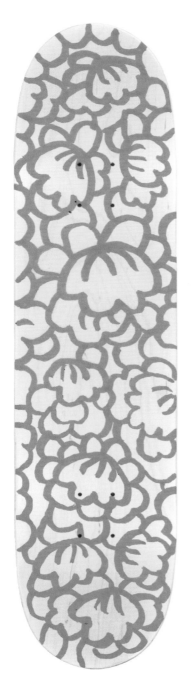

Customize
your very own
skateboard, dude!
(see page 95)

Embellish this envelope in your own, distinctive style! *(see page 102)*

 Draw icons to represent the following words.

FRIENDS

ARTISTS

Draw icons to represent the following words.

TEACHERS

MAKERS

Different strokes ... See how
different lettering techniques
affect your perception of
the same word in different
languages. Create your own
letter design for the word "play."
This is my sans serif typeface.
What can you come up with?

Spanish

Decorate this shoe with a pattern of scribbles, marks, words, lines, or doodles!
[see page 43]

The Hatch

I think the scribble can have a lot of meaning. It is a gesture of life's collective confusion and can reflect strong emotion.

SCRIBBLE HERE!

Illustrate a wise saying, whether famous or original!

APPROACH CREATIVITY AS A PRACTICE, NOT AS A PROFESSION.

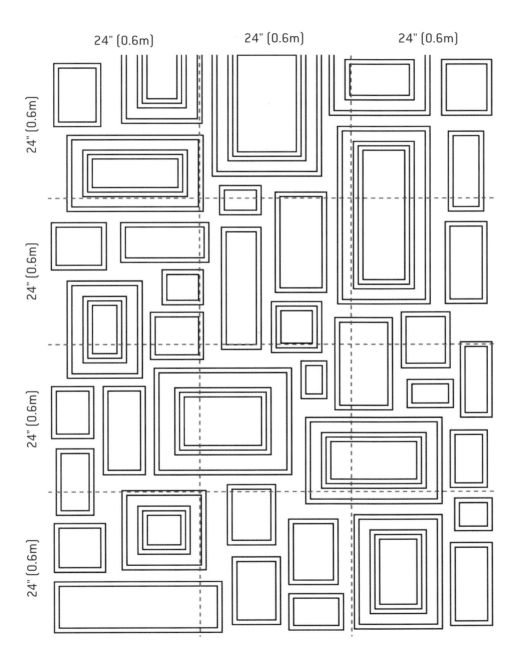

24" (0.6m) 24" (0.6m) 24" (0.6m)

24" (0.6m)

24" (0.6m)

24" (0.6m)

24" (0.6m)

Plan out a mural for a wall space in your home or office. *(see page 87)*

Write a note to a loved
one in an elaborate script.
(see page 80)

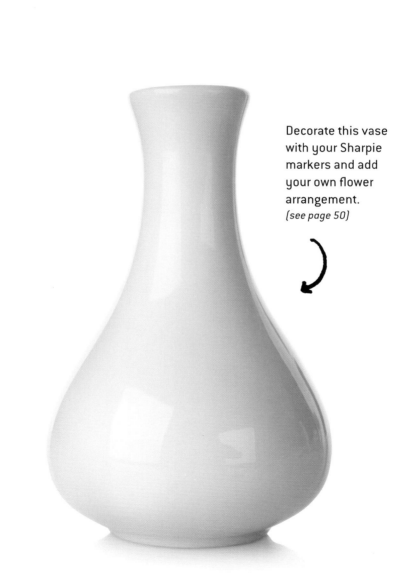

Decorate this vase
with your Sharpie
markers and add
your own flower
arrangement.
(see page 50)

German

Different strokes ... See how
different lettering techniques affect
your perception of the same word in
different languages. Create your own
letter design for the word "play." This is
a serif typeface. What kind will you use?

The Wiggie

Scribbles represent the beauty of life and the process of living the questions. Here's a scribble you might make. Now try some of your own!

SCRIBBLE HERE!

Get ready for your lunch date.
Artfully decorate this lunch bag!
(see page 90)

Memoir

Illustrate an expressive
word in a different way to
accentuate the meaning.
[see page 70]

Illustrate a historical
fact you've learned about
Sharpie markers in an
original, colorful way.
(see pages 16–17)

Use your Sharpie
marker to record the
details of an important
event in your life.

THE WORK YOU OUGHT TO BE DOING IS THE WORK YOU SHOULD BE DOING.